WALKING TOWARD SOLSTICE

MONGREL EMPIRE PRESS
NORMAN, OKLAHOMA, UNITED STATES OF AMERICA

Norman, Oklahoma

2012

FIRST EDITION, 2012
Copyright © 2012 by Anca Vlasopolos
All rights reserved.

ISBN-13: 978-0-9833052-8-6

Except for fair use in reviews and/or scholarly considerations, no part of this book may be reproduced, performed, recorded, or otherwise transmitted without the written consent of the author and the permission of the publisher.

Cover Image: *Walking Toward Solstice*
© 2012 by Olivia V. Ambrogio

All photographs included in this book are
© 2012 by Olivia V. Ambrogio

MONGREL EMPIRE PRESS
NORMAN, OK

ONLINE CATALOGUE: WWW.MONGRELEMPIRE.ORG

This publisher is a proud member of

COUNCIL OF LITERARY MAGAZINES & PRESSES
www.clmp.org

Book Design: Mongrel Empire Press using iWork Pages.

Walking Toward Solstice

Anca Vlasopolos

Acknowledgments

"Above the Bird's Eye View" and "Wedded Bliss," *Mascara Literary Review.*

"August Teetering," *Aries.*

"Before Fox Creek Ran Red," *Into the Teeth of the Wind.*

"Faithful, in My Fashion," *Barnwood International.*

"Fin d'année" and "So Short Past Solstice," *Visions International*

"Foreclosed," *Language and Culture Journal.*

"Night Vision" and "All at Once Seeds," *Whimperbang.*

"Re-Becoming," *Hot Metal Press.*

"Short of Breath," *Origami Condom.*

"Sparrow's Fall," *Earth Speak Magazine.*

"Surface Tension," *Porcupine.*

Contents

Persimmon Passion	1
Above the Bird's Eye View	3
Short of Breath	4
August Teetering	7
Wind Toys	8
Foreclosed	10
Ringmaster Beatriz	13
All at Once Seeds	14
Scissors Rock Paper	15
Vase in My Keeping	17
Saved and Spent	18
Nothing but Wind	21
With Little Sunlight	22
So Short Past Solstice	25
A Wish for the Second Daughter	26
Before Fox Creek Ran Red	27
Lost Glow	28
Wedded Bliss	31
In 2050	32
Too Long in One Place	33
Above the Lansing Rally	35
Independence, of Us	37
In Ohio Ravenna	38
Those Never Written	39
We Balloons	41
Arithmetic	42
O Lovely Steed	45
Night Vision	46
First Signs	47
Tonight Midsummer	49
Lost in Modernity	51
The Note Beneath	52

Contents

Signals Over Water	53
An Evening in Tulle	55
Faithful, in My Fashion	56
Re-Becoming	59
Changeling Day	61
Halloween Denial	63
Fin d'année	64
No Uncertainty	65
The Disillusionment of Ice	67
Recession	69
Dark Deeds	70
One Snowy Northern Night	71
Midwinter Flânerie	73
Burying the Next-Door Neighbor	74
O the Animals	76
Disposal	78
Shared PET Imaging	79
In Dream	81
Surface Tension	82
Showcase at the Convalescent Center	83
Those Who Build (are not gay this time—pace WBY)	84
Thirty Six Replicas of Camel-Leg Bones	85
Winter's Tale	86
First Thaw, March 1, 2003	89
Two Months Past Solstice	90
Spring Phenomena	91
Small Signs	92
Vying with Olympians	94
Spheres	95
Walking Toward Solstice	98

To Olivia V. Ambrogio, who has given visual voice to my poems

Persimmon Passion

this unrelenting winter we put aside
thoughts of global warming

as we huddle like bears in caves
sucking at their claws

yet somehow they arrive
in cardboard cages

we know from places too far away
to justify our greed

but nothing no stab of guilt
will keep me from cracking this safe

> where hide in anti-natural nests
> set out in perfect rows

> these dented thin-skinned globes
> consistency of breasts

> color of garish flamingly exotic
> sunsets on far-off islands

will keep me from putting mouth
to pulp till i suck into my shriveled self

all this munificent light

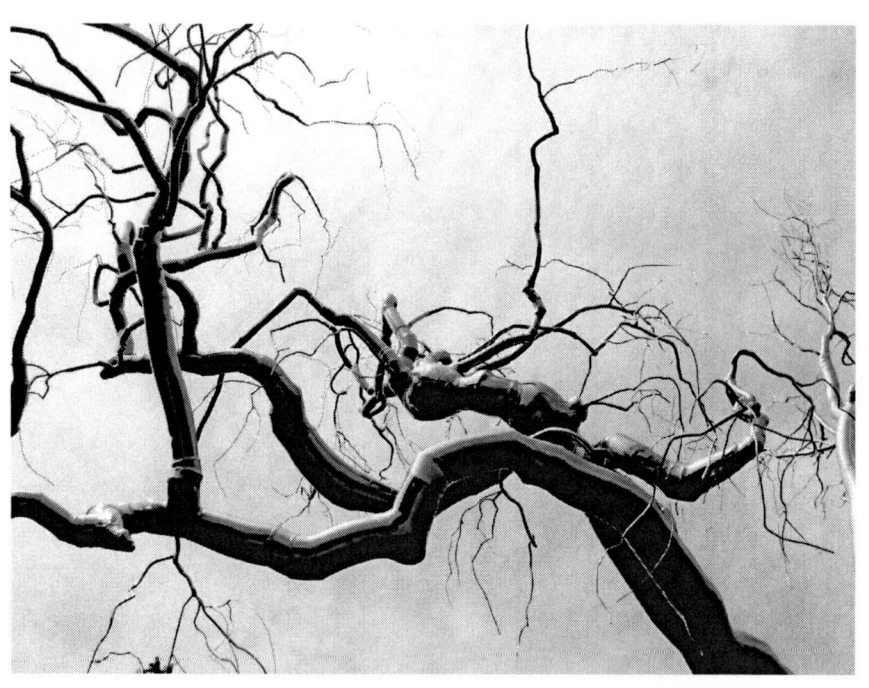

Above the Bird's Eye View

winter this year
sprang
a lynx
from still full-leaved branches

huge paws of wind to bat us
should we raise eyes toward light
or sigh at the thin horizon
arriving earlier each day

in this desolation in drab and gray
i look from a second-story window
see him—olive camouflage
for a pulsebeat unzipped

his rich summer gold
streaking
sun bullet
bursting through lynx dominion

Short of Breath

this pile of paving stones on the chest
not gone not one lifted

yet I begin dimly
to recollect

oppressive repetitive dreams:
I left for somewhere and forgot you

never picked up the pen
never the telepathic receiver

simply because I'd not thought
just that—not thought

of you and I wonder
what made me tread

the infernal mill of these dreams
when in daylight you know do you?

you know not a day subtracts itself
from my ledger

that I have not mirrored a stray
thought gesture pinch of herbs

all from that repertoire
always full granary that
was you

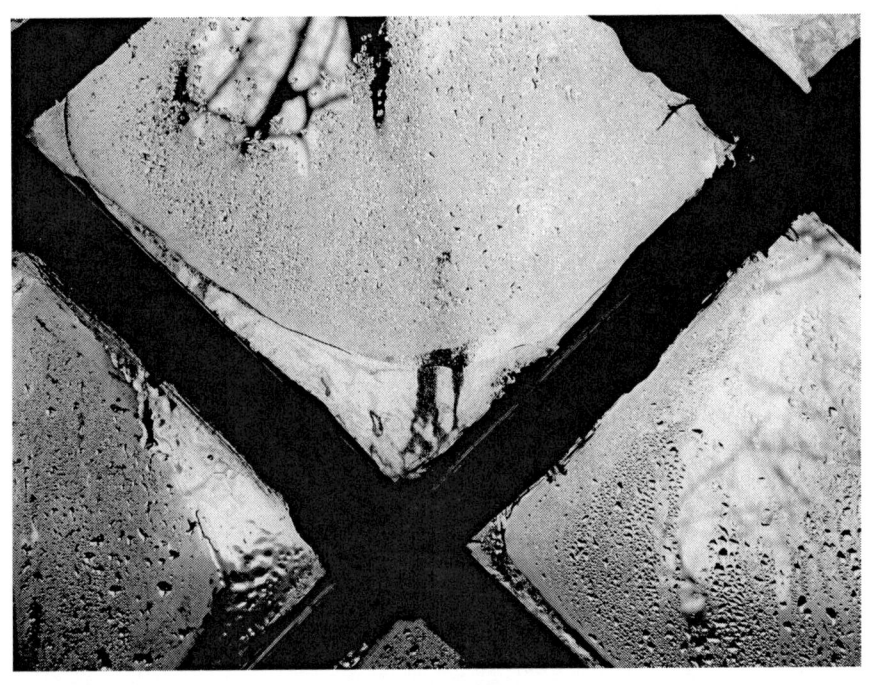

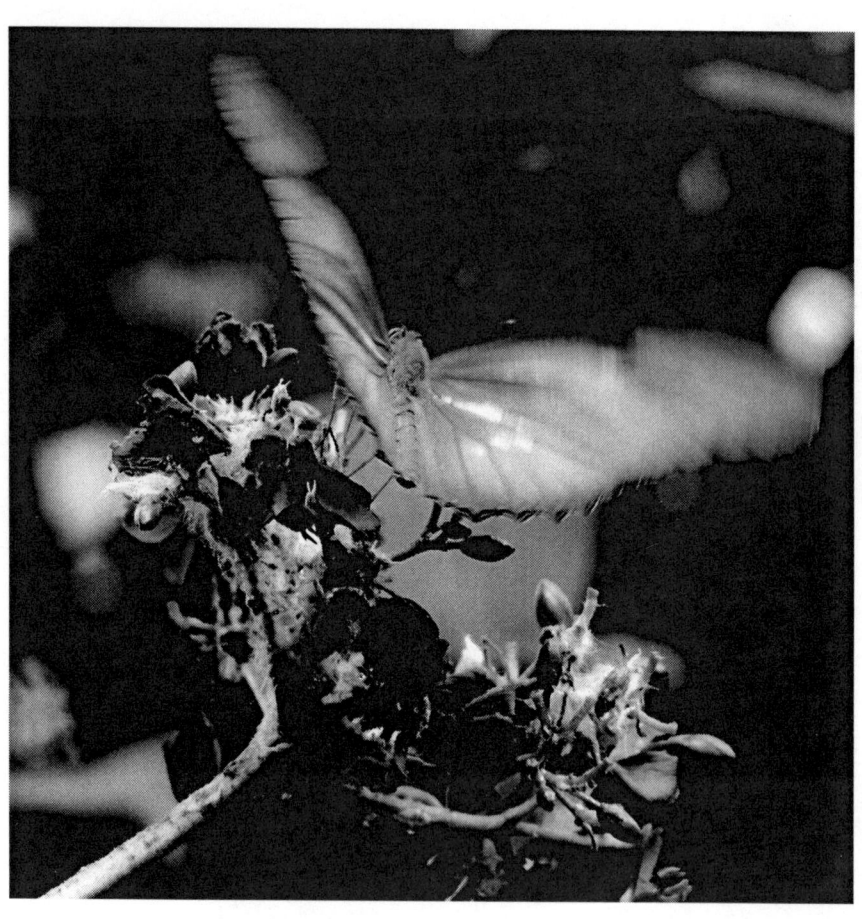

August Teetering

scale seesaw
last august day Michigan ditches Ohio undulations
it won't take as much as the weight
 of the orthodox acorn not so much
 as spiky buckeyes
 pungent placenta of walnuts
no, not so much

cattails willows siberian elms clothing
themselves streaming in the nearly
not yet equinoctic light
not gold effulgence
but painful brilliance
steel blades slicing the eye

not even ethereal rising of egret shifting
for opener waters
rising like a good dream against trucks fumes ads of interstate
not the sacs almost—not yet—bursting
 with milkweed seeds taking off
 in their parachute silks
just one
 husk of cicada
 leaf detaching in slow motion
 stalk of queen anne's lace bowing to drought
and
we tip dip
fall
into
birth canal
of the year

Wind Toys

can you help
hearing

these imposters
 pin oaks
 a copper beech
pretending
to evergreenness
holding on
like women
much past their prime

to these tobacco dry-sucked leaves
taffeta rags
wind ruffles rattles
like backstage metal sheets

twisting
the passing heart
with winter fear

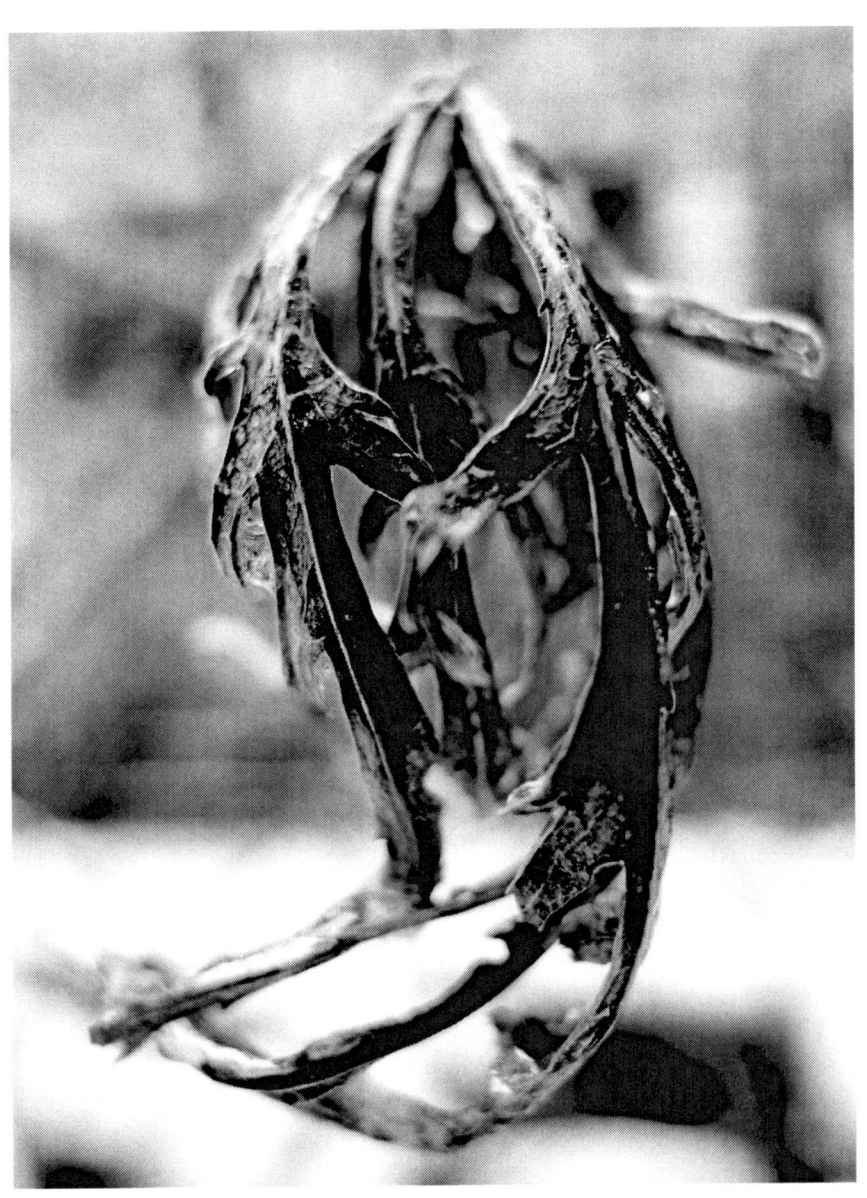

FORECLOSED

because we leave
before the end
we do not know the sound
slab makes as it seals
darkness beneath

but we have heard pounding
machine-gun staplers
putting up boards
to shut up unprotected openings

this house our shared past
is in arrears
our taxes that small sum of joy
we've forgotten to pay
has caught up

and see the front door and windows
facing the world
shuttered
chain and lock barring
side doors

shards lie in wait among tall grasses
jagged teeth still in frames
slash
twilight
pooling
thick glistening
blood
from fresh
wounds

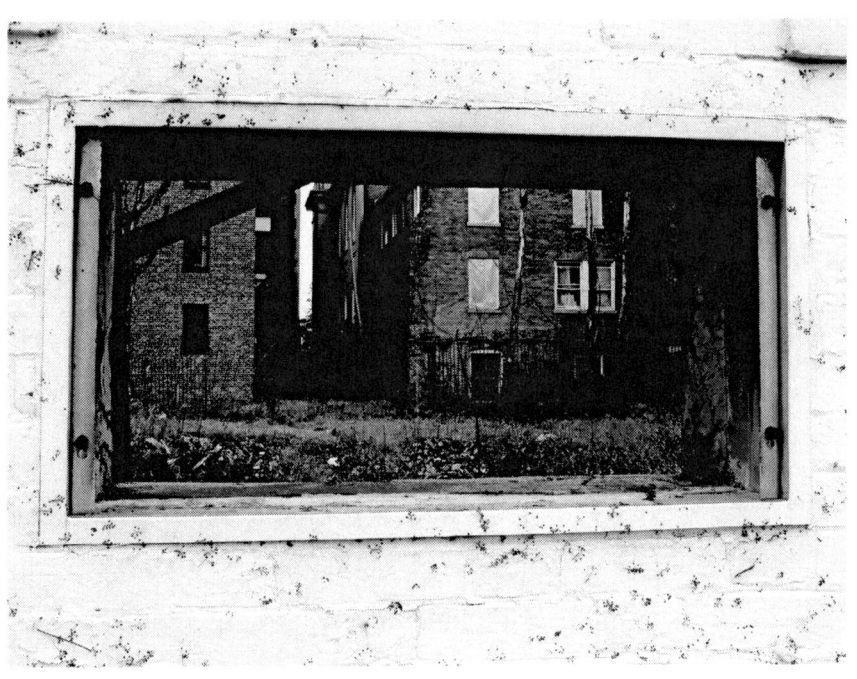

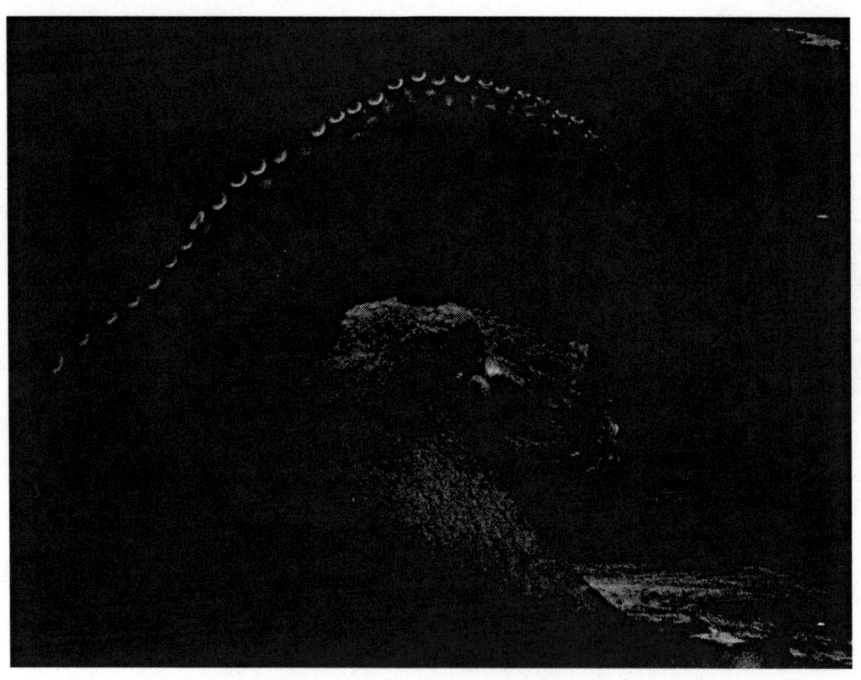

Ringmaster Beatriz

they tumble out
jump scrambling like snakes out of a joker's can
do loop-de-loops
plunging to sawdust only to somersault
bow
exit
laughing
or crying it's
so hard to see under face paint

will she make a complete spectacle our expected
beginning, middle, and end
will her memories of there . . . in Guatemala—
here . . . where?
ever reshuffle to a whole deck
will the joker forever be popping
the hangman showing his upside smile
Maria Teresa crashing as she moves between
San Pedro en Po and the town where god grew up
in Israel
the then-father's buttocks raked by crocodile teeth
the now-mother always drinking coffee and being
on edge
will the lost baby brother stop crying and waking her up

lord of misrule brother mischief at least now at the end
of a phone cord a drive
no longer is sawed in half no longer enters the magic box
whence he disappears
no revival of that show of shows
no daily tears

All at Once Seeds

in my papi's garden there were mangoes, mangoes and bananas
but pomegranates we ate one kernel at a time
so we'd stay clean and the fruit would keep for days

in my papi's garden, she says, mi papi, same words, same
inflection as when she calls her new father
in whose garden there are no mangoes, no bananas
only leaves to be raked, wild strawberries, the occasional
raspberry escaped from robin's cocked eye

and at the kitchen table we eat a whole swollen
pomegranate down to the rind
rain of fuchsia drops
trigger remembrance, dream, wish
as she and I paint ourselves in blood

Scissors Rock Paper

she had
in a small voice
asked
once
and again
for the yellow
tissue
the gift came wrapped in
and for the scissors
please?
a small bald doll
waiting
for
a Cinderella gold
dress

she asked
for
it
she did
did she
not
that little whiny voice
that tentative
please?
as if in fear
goddammit
of what?

now she knows
now
under
the boulder
immovable tombslab
of this
most
declarative
fist

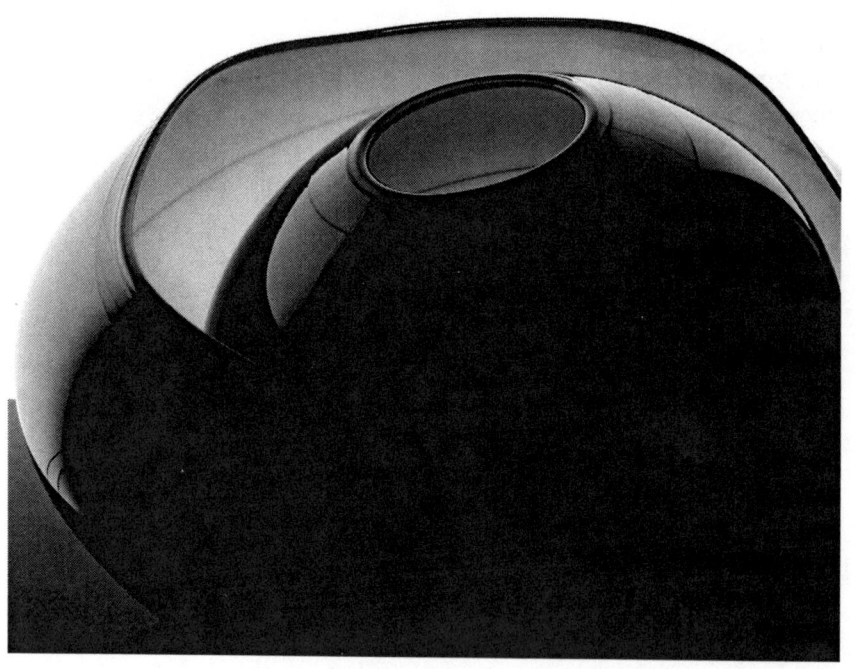

Vase in My Keeping

air feeling trapped inside
held tenuously
in this home
wavering cylinder
transparencies
and magenta bursts

in dream
i saw how it would go
saw how the air
raged
to shatter
that tremulous
hold

even my hands
held ever so
tentatively
round
that sinuous shape
 i knew
would
heat
that angry
air
hasten
 no!
urge
its
splintering
 shards blood drops
break

Saved and Spent

we could have saved the child
left belly swelling next to mother's body in Darfur

we could have saved the five-year-old
raped now trailing behind the one good doctor

>in the one hospital of Congo where they try to suture
>bayonet wounds to the groin

we could have saved the Chinese girl note
pinned to pinafore—she's a good child

we could have saved Korean twins born
with cleft palates left on orphanage steps

we could have saved the girl with matted hair
used to sell drugs under the bridge

>in Bogota where she found then lost
>a bigger boy to watch over her

we could have saved the child left to fry
in a closed car in summer in Detroit

but we chose you left in *El hogar del jardin*
alone and older than the four placed siblings

we chose you based on a written plea
from new father of two of your brothers

>who came here where we live and we
>thought to offer you more than our meagerness

but you did not chose
us and you will not be saved

and you regard perhaps so very justly
this a transaction wherein you have been bought

so you would rather sell yourself at lowest price
than suffer manacles forged by a force you cannot see as love

Nothing but Wind

watch that large leaf of hosta
catch this maddened wind
see her slapped
turned
upon herself

you must say
there is nothing I can do
even if
the rogue
breaks her
clear of her stem

but for her it is fall

for you
my lost girl
it's still spring
even though you've let yourself
slide into
ice caverns
be shredded by fangs
of stalagmites
impaled
on icicles
burned by
cigars
marred by
edges of stairs you hit on your way down

wind chases off
dull fall rain
and brilliant skies
redress
this unpropitious day

what gentle sun
may heal
tossed leaf
cracked soul?

With Little Sunlight

in deep lush forest where you began
with little sunlight and salted rain

there's a casita under the trees
all camouflaged by liana vines

in the casita there are four chambers
none with a window all throbbing wild

in one of them there is a casket
of simple wood subject to worm

inside the casket there is a box
not magical not cloisonné just square and squat

inside the box there's a red cushion
neither of velvet nor of silk

on that homespun there rests an egg
not of the bluebird of happiness

just a small egg speckled like sparrow's
looking benign holding your sorrow

over the years you lose your way
forget the path to the casita

lose the three keys to outer door
to inner chamber to casket box

the egg awaits in warmth of jungle
in that hushed air its due release

the egg imagines incipient cracks
tentative ta

the casket dreams of tunneled burrows
quietly tearing its sides apart

till wood in shavings falls in small heaps
carried away by wakeful ants

chambers keep hope for seeping walls
an end of throbbing as that bad blood

runs without splashing into the ground
discreet black humus so much enriched

casita hopes for chicken legs
a chicken shape so it can run

into the glen to peck at gold
fall into maw of streak jaguar

but you remember not the path
and you have lost three keys besides

so in lush forest where you began
with little sunlight and salted rain

that potent sorrow still waits and waits
inside the egg for liberty

So Short Past Solstice

the lavender sprig sucks back its flowers
till they're no more than gnats' discarded
crumpled chiffons

it is already past midsummer
each day throws wantonly away another
minute or two of light

flowers aspire to fruit and fruit
to seed
second nests near their hatchlings

you say
there's all of summer yet before us still
but dark descends on walks sunny just days ago

lavender has closed up store
will yield familiar pungent seaside scent
like hopes only when crushed a bit

A Wish for the Second Daughter

may we hope this vision
 through scratched scarred lenses
 capillaries routinely leaking
 so battered into inevitability
 by that tin can—experience—
 tagging along
 drumming maddening
 repetitions
of this
our
 as only we determined
girl
walking unknowing
into rock-broken waves
 current a sinewed arm
 pulling her under
 so she will surface
 and founder
 and bob up
 and go down
 till swirls eddies
 will mock our straining sight
 show us
 nothing
 but water

may we hope that this vision
will cut
like a film scene
like a computer screen gone blank
in a surge

may we hope
that these rapids
hide secret pools
hope
that the waters will
part

BEFORE FOX CREEK RAN RED

dig
one foot down
hit clay so compact you could knead it
for a pot

here
where almost a hundred years ago
French farms embellished with flirty blossomed pears
made way for
Anglo lakeside manses

here
under our very house
under this street
once ran Black Creek

water obsidian
in narrow slanting shafts
through canopy
elms cottonwoods willows
reeds sweetgrass

now lawns overfed
like present folk
pesticided
spread like a fad a plague
creek trapped in sewer pipes

only the birds
still come along these now dry paths
still seek lush tender cover
still sweet free-flowing water

Lost Glow

the dog and I walk these old streets
lined with old trees
drilled so by woodpeckers
pieces that fall are stones porous from waves

I pick up one holey souvenir
the dog thinks anything I grab
must be good to eat

together we choose horse chestnuts
the few left unscarred by squirrels' teeth
he mouths them drops them smells inside
their hedgehog afterbirths

I run my thumb over smooth skins
pocket one another
reaching across more than fifty years
when I would bring my cache home
and luscious luster
seemed then to linger into the cold days
my life still stretching into infinity

now on the windowsill
in two days at best
they grow dull gaunt
memento of what I can't retrieve

Wedded Bliss

gold bands glint
over a plastic bucket
where two pairs of hands
lovingly
gut
fish no bigger
than the hands

this could be a portrait
of marriage
man and woman
in harmonious
complicity
fish gored bleeding
from the side

In 2050

you whom I've not seen for nearly
 fifty years and who for all I know
 may no longer be alive
and I

in nine-year-old arithmetical
arrogance
calculated that on the stroke
of midnight 2000

we'd be fifty-one
and we dissolved
in helpless hilarity

not much after
yet another meteor
of politics
struck smack into our childhoods
spattered us—small drops—
to the four winds

do you in that torn crescent
 whence rose the visions troubling the world
like me here
 in the northern part of the wild continent
hear in projections, predictions, prognostications
"in 2032 the oceans will have risen. . . ."
"by 2028 there will be more than eight billion humans. . . ."
"in 2050 every American. . . ."

and quickly calculate
by then I'll most likely
 most probably
 most certainly
be dead?

depending on the news (those meteors still shower our poor planet)
perhaps
lost friend
we may again
give laughter its full vent

Too Long in One Place

horizon
 stubbornly sullen
above
a wall of milk
 on fire
over it
strands
of glacier hearts
 smiting
beneath gray frowns

wake me from sleep of death
without a second's pause
to reassemble slackened jaw
 loosed teeth
and i'll affirm

midwinter sunset
eastern skies

Detroit

ABOVE THE LANSING RALLY

in a horrendous month of rains and winter cold
the gods favoring common people
for once seemed to prevail

a crisp almost caressing April day
the lawn before the Capitol crowded with tents tables
 podiums
 microphones blaring
 people taking up the chants
"this is OUR House!" "this is OUR House!'

above
disturbed but not enough
to be moved off
 for
 had they not withstood
 the forests downed
 marshes filled in
 meadows paved over
 noise poisons rises that trapped space murderous
 squares of solid light
cedar waxwings flared their banded tails
chittered to chide this rowdy bunch
flitted uneasily
from pine to locust to sycamore
never making up minds to leave
as yet

since they
 not we
 late comers destroyers of each other's livelihoods and
 sometimes lives
had dug indelible
these channels
of their travels
"this is OUR House"
for what to us must be
 though we waste not a thought on it
infinitude

INDEPENDENCE, OF US

on the way home from an elderly Fourth of July
eastern skies in the populous city still many miles away
break open in firebursts

while to the south the low dark clouds
shrivel away like paper burnt from the other side
revealing an improbable waxing moon

outbrighting
our fake stars

In Ohio Ravenna

others have noticed
because obsession lies writ large
on this continent's skin

first all the new's—York Amsterdam Bedford
 Orleans
then the firsts as if nothing preceded them
Paris Rome Ravenna

 this last
 evoking a girl with dark streaming tresses
 whose speech lilts like recitative

how hollowed with longing
those who in the wilderness cried
los angeles bethlehem gilead

how brazen their stabs of desire
to name tangled forests black marsh pigs' island
belle isle beaubien beaufait belle rive

names to hold off immensity
light incommensurate darkness
make tenuous tattered tents against the foreign-whispering winds

Those Never Written

at my mother's cutting board i
learned what came first
or rather what came inextricably
together

the hen my mother dissected for at least
three of our dinners
 meat being so very dear
held deep inside her a pouch
of eggs like amber beads
going from penpoint to almost full size

so when i too go
should there be reason to cut me up
will all these bottled
stored
nearly forgotten
poems
i didn't write
bunch up
like hen eggs clusters of hanging grapes

or line up
neatly
a string of maiming
debris
waiting to be sheathed
into perhaps
unlikely
pearls?

We Balloons

held not even tightly
 like curing cheeses
 hung sausages wineskins
we are

our containers
 grow more wan like weary daffodils
 sag crack
 to the call
 we think
 of gravity

but
 no
each atom
each molecule
each cell
yearns for that burst of freedom
 to entropy

so
dying
 you see
is neither
restoration to celestial glory
nor
reconstitutions to the lowly grub

it's
 brief
 sweet
 utter
unalliance
a chortled salutation to
 dear
Chaos

Arithmetic

gone
the woman is gone
the white woman in the window is gone
the white plaster woman in the window of the tiled building is gone
the white plaster armless woman in the window of the tiled building called Goeschel is gone
the white plaster armless torso of a woman in the triangled window of the tiled building called Goeschel is gone
the white plaster armless torso model of a woman in the triangled window of the white-tiled building called Goeschel is gone
the white plaster armless torso model for hats, for lingerie? of a woman in the dingy triangled window of the white-tiled, gold-and-black-fringed building called Goeschel is gone
the white plaster armless torso model for hats, for lingerie? of an impossible woman in the dingy wide-vista triangled window of the white-tiled, gold-and-black-fringed building called Goeschel at the corner of Gratiot and Mack is gone
the white plaster armless torso model for hats, for lingerie? of someone's impossibly perfect woman in the dingy wide-vista nine-foot triangled window of the white-tiled, gold-and-black-fringed building called Goeschel, with a firm still named Solomon Brothers downstairs, at the corner of Gratiot and Mack is gone
the white plaster armless torso model for hats, for lingerie? of someone's impossibly perfect silent woman in the dingy wide-vista nine-foot triangled window of the white-tiled, gold-and-black-fringed building called Goeschel, with a firm still named Solomon Brothers that sold jewelry downstairs, at the corner of Gratiot and Mack is gone
the white plaster armless torso model for hats, for lingerie? of someone's impossibly perfect silent blind woman posed to look out in the dingy wide-vista nine-foot triangled ballroom window of the white-tiled, gold-and-black-fringed building called Goeschel, with a firm still named Solomon Brothers that sold jewelry downstairs, at the corner of Gratiot and Mack in Detroit is gone

 the white plaster armless torso model for hats, for lingerie? of someone's impossibly perfect silent blind woman posed to look out on what's left in the dingy wide-vista nine-foot triangled ballroom window of the white-tiled, gold-and-black-fringed building called Goeschel, with a firm still named Solomon Brothers that stopped selling jewelry downstairs ages ago, at the corner of Gratiot and Mack in Detroit is gone

 the white plaster armless torso of someone's impossibly perfect woman in the dingy window of the white-tiled, gold-and-black-fringed building at the corner of Gratiot and Mack in Detroit is gone

 the white plaster woman in the window of the building at the corner of Gratiot and Mack in Detroit is gone

 the woman in the window is gone

 gone

O Lovely Steed

at night tight rein my lids
daytime hearing hearing hearing
whines: motors radio voices stray spat-out words

i ride

my lovely steed
dappled
fierce
shod with diamantine flashes
cutting
deep
through
every substrate

i ride

foam in the mouth
glistening
flanks
eye lit coal

mane trail spume of towering waves

ride
this
between my thighs
my hands
this sinew
that sustains

o lovely steed

Anger
my own

Night Vision

first
 ahead
 a cut-out of night resisting
 headlights' evaporation
then
 the tread on brakes
 slow-motion trajectory
 few seconds left before
 hitting that final wall
but o so slow the cut-out
moves with the grace of long skittish legs

you say
hell
you manage out of peripheral eye
to see mother and fawn
still perilously close
to this swath we've cut through their world
that now after all is
the only way across

and
 as the sky clears of trees
you notice the three-quarter moon
 like a silver-paper disk smudged
 by the heel of night's palm
your breath just now coming back to itself
utters
thanks, injured-head moon, for letting
me
see
enough

FIRST SIGNS

this afternoon a first mildness
 after a hundred years of winter's thrall

a girl just on the edge of all the woes of love
let dangle her arm outside the window of a speeding car

watched her long fingers trail
thrill the warm skin of this rogue breeze

TONIGHT MIDSUMMER

tonight Midsummer
should i traipse through
mosquito-infested grasses
shrub boughs spraying
skin-shivery drops
burr thorn cobweb
for that magic flower
the one
 you know
blooming only this once

i have lost touch
with languages of humans
love is a worm-bored gourd
holding nothingness
hatred writhes—a defanged
mangled rattler
used by peddlers of those rocks
called faith

and i forget who cries from foliage
at dawn's shafts

so yes i'll brave
bite scratch lyme disease
to seek the one
that grants me
hearing
to understand
what now i feebly call
tumult
heaving
sighs
murmur
susurration

the words and grammar and syntax
of the trees

LOST IN MODERNITY

it used to be
 full-breasted open-bloused
Summer
reclined upon the cusp of July-August
 spinning out of her
 many-teated self
 strands of cotton candy
 shielding us like mother's palm against fierce rays
 sugaring our days
 filled with long silences
 pierced by alarm-like peeps of fledgling
 exo-skeleton cidada danses macabres

we devour her globes of plenitude
 tomatoes apricots nectarines tiny raspberry
cups
 green of honeydew sunset of cantalopes

but now
 as she lies profligately spending
 her last
 waning each day before our eyes
we drill her silences
infect the plume of sugared air
each minute of each day
motorboats motorbikes jetskys chainsaws mowers hedgers trimmers
power washers
now that nothing seems to be made or tamed by hand

her body
 ruptured to shards
still spins
 haphazard strands like tattered spiderwebs
 whose sweetness
we taste
 if at all
 in scorching violent
 haste

The Note Beneath

wind tugs at late-summer warmth
 dog worrying a rag

the dream comes back at me
 wondrous spiderweb
 the length of doorway
 hummingbird stuck fast
 like emerald drop of dew
 my hands free
 then hold

as earlier in summer I held
broken enameled body
giving up its breath

unsubtle messengers
carrying
or pregnant with
our coming loss

Signals Over Water

i raise binoculars for birds in flight
see
 gold thick snake
 of braid over shoulder breast
the baseball-capped girl in her kayak
 stilled over water like hovering dragonfly
 under hooded skies

today lake runs the color of eggplant flesh

her notebook
 gull belly flashing
semaphores
 (i think, to me)
as each
 i burdened older landlocked even
 on this tongue of asphalt
 thrust into the water
 she afloat in vigor of young womanhood
pen in hand
begins
to chart
 away from populous shore
our solitary island

this white space

An Evening in Tulle

vapor
from this intense abridged summer day
in september

the sun does not so much
sink
as drown
languid
exhaling fatigued
pink-greys

lake
a winkle shell

smoke from a barge
and every single bird
fly true northeast
as if they sought renewal

only the idiot
on his jet skis
sunders
this fin-de-siècle
quiescent
lassitude

Faithful, in My Fashion

where are they
your fairweather friends

this wind-advisory day
 boat battened down against waves
 laden with algae
 lake's tresses tossed like a wild beauty's in dance

the guard
in his weatherized techno hut
at this residents-only park
thinks me
 woman of a certain age I've become
harmless
waves away my attempt to fumble
under my poncho for the pass

but ring-billed gulls in a row on the pier's parapet
 as if to pose for the fall cover of a magazine—
 "St. Clair in Late-September Rain"
take affright
as orange plastic billows round me

I alone am here
to cast bread upon waters

on this day of sudden squalls
sunshine brief on Canadian shore
clouds hurrying to the less restricted skies
over the Huron
up the St. Lawrence
off at large on Atlantic

but I am here

on this day of white caps
strips of sun like long spotlights

here

watching green chase gray
hearing distress of these mostly still green leaves pushed slapped
 baskets of geranium
 perilously swaying

here

thinking of all those I've loved now
where I
 like these leaves
 tinged with endings
know I will follow
hearing
gulls caught in currents
shriek

 September 28
 Yom Kippur, 5070

Re-Becoming

this fall the sun visits achingly
in short bursts
like a faraway daughter

here on what we've made
of Black Marsh
creeks so covered that water
only glancingly caught light
in a dark web
like wing fluttering
mad to untangle itself
into free air
in this place still calling back
to its names—Moross, Grand Marais,
Fox Creek—
it is weeping
from a sky mocking us
all summer with pretense of rain
now hiding itself
behind this dark lid

lifted now
as one might do a pot needing
just a quick check

a brief streak
fires the turning maple dying ash
these coal leaves waiting
trapped in the shrubs
to smolder

CHANGELING DAY

you will tell me it's only
light effects
reflection
refractions
old tale—mere shadows on a screen of stone

yet I tell you
where I find myself
is not the same

today sun and water
collude
to a different end
so much so
that for my aging eyes
they make another world

ashen lid broken
and this crinkled sheet of shards and diamond dust
is out
to bedazzle
like a beauty shaking
her rippling locks

near shore water
opens shallows
clams translucent crayfish secrets
while waves relentless heave
wear away sea walls

these trees firing up only two days ago
sedately rust to old gold and worn russet
save when sun shoots them through
and honeypoison tips
make mirrors of leaves' undersides

this glamor even gulls geese
know and
shrilly
utter

Halloween Denial

littered with hokey symbols
—now
just as trees shed their flesh and froth—
the park shivers with cheers
some teen team
sports among skeletons
a lurid beat-up boat flying the skull and bones
floats uncertainly on a pool scummy from disuse
and horror-movie themes blast from the speakers
that all summer long broadcast commercials to the sultry air

farther the lake leaden as the sky
frets in the wells
against confinement of shore's iron walls

all clarity is gone

muckgreen algae stretch balletic
reach toward open space
 drowned maidens
 calling
 sucking in
 lovers too desperate
 to mock
 death

Fin d'Année

watch how this mid-november sun
 freed from unraveled nets of leaves
glazes west windows
 as if
 in mansions
 no less than hovels
 ruins
a million-watt chandelier
were lit
to start
the year-end ball

No Uncertainty

although this november-end weather
exhales still
sweetly
so gnats dance summer
 only
 hours earlier

there's no uncertainty
in herring gulls' wings breasts
 grey inside audacious yet black-ink-bound span
 determined white
they have returned to themselves
undistracted
by sex and human waste

in the emptied marina
waves fall hungrily one upon the other
 no longer trapped among hulls
for now
 in the time between our excess
 and the unscrupulous ice
at large

The Disillusionment of Ice

when freed from the corset of ice
the lake—you think—heaves
with underwater breath
gentle sighs under summer's caress
palpitating
anger-stricken
 by wind's slaps and blows

but today
as sunlight slices itself
on these shark tips
 of waves caught
 in mid-motion
 by merciless vise
you are forced
 faceskin cracking
 eyeballs gushing to keep from frost
to acknowledge
your difference

nothing here
keeps human proportions semblances
on this day

oh, it may look like white-grey edges of wounds
like sweet life's blood seeping
but it is only elements
and it would not blink
at deciphering you
into component molecules

RECESSION

this year the solstice brought no reprieve
ice flowers grow overnight
 obscuring the falling flakes
 breaking our wills with their unliving
 shapes
mockers of what we yearn for
leaf, fern unfurling

yet we are on the clement side of the window
and know
 for how can we
 even through heavy haze
 of warm rum
 forget
there are those
for whom
this frosted glass
is as hard a barrier
as for the winged
who in fright
perhaps despair
smash like snowballs
against it
leaving no more
than
a puff
a smear
a cloud
shredding
at incipient
light

Dark Deeds

in the new-washed february sky
the waxing moon
lingered
ragged bloodless
like afterbirth

if i didn't know better
i'd have thought the sky
shoved to break through
so wan was she

that night she hadn't moved
but shone white-gold
against a pallid backdrop
as if fangs on her dark side
sucked out that blue intensity

One Snowy Northern Night

not caught, no,
in the motion detector's spotlight
for they neither float nor dance
glare slips off them
they slice darkness
minuscule knives
pared-down razors
yet translucent
like fish scales

you watch
breath hypnotized
so the window doesn't even fog
recollection floods you
like blood pooling
that weird childhood tale
evil gnomes, mirror, the shattering
shards, yes,
slicing
lasers
entering without scars
eyes
organs
piling their ice castles
setting up
imperiously kissing us
out of heart
out of sight

MIDWINTER FLÂNERIE

these bone-powdering
midwinter days

in the weird tilt
of our elliptical planet

noon is not shadowless
the dog and i stretched out to more than twice the size

as i advance into bleak time
of my own seasons

nothing at zenith has any longer
that clarity of just itself

simplicity grows tentacles
dragging youth's certainties

to these mock dimensions
woman with dog—Quixote walking a long creature

Burying the Next-Door Neighbor

like patches off an old quilt beaten for
dust her mind began to unravel

detach float settle unexpectedly
end up being fingered stepped on each day

she would stop my garden travails
air at five-minute intervals the same griefs

stuck record looped tape
memory digging wrongs

then she began to forget how to drink
feed breathe yet not how to love

for her mind's divorce decree from her body
didn't betray dog and cats in her care

yet despite that coming apart
or perhaps because the holding together

no longer scattered laser focus of knowing
she prophesied her near ones' raptor gyres

and they swooped as she told me and told
and they carried her away in the night

now a dumpster sits in the driveway
colossal black bags appear at the curb

her silly pretty excessive ornaments
extension cords flowerpot lifetime detritus

stuff that would with a bit of attention
outlive us all—all chucked to enhance Property

the chattering dog the spooked cats
waited their turn at the shelter to go up in smoke

but she in her regulation-size dumpster
has not even that hope

on an ugly commercial street tended by youngsters
plugged in to their pleasure devices

my neighbor dreams of her garden frets
about her animals sits buried alive

O THE ANIMALS

o the animals my father had
the monkey his father the ship mechanic
brought home
and left
who could only be lured down
to my grandmother's sharp kitchen
full of cuts—knives and words—
by my father a boy flourishing bananas
under the acacia tree

the pekinese he ran through smoke
screams of sirens
home to carry in his one good arm
to the shelter
when bombs burst over Bucharest
derision indignation at a grown man
bringing a stupid little dog
to safety

father
you made your escape
there where we may send our questions
but at least in this life never hear reply
before i was old enough
had wits (perhaps wits not) to
ask
how did your animals die

Disposal

in the front yard next door
the plaster venus lost her head
a long time ago
in a gesture perhaps
of solidarity
with the neighbor beginning
to dispense with her mind

today i saw her wrenched
so only her pedestal's left
frozen to the ground
her now footless body
a stump to hold open
the hell door
to a dumpster bigger than a hospital room

on the lawn
the blue unicorn
 legs whacked out from under
 by her who used to live there
 so the children riding
 wouldn't fall too far down
 horn gone and replaced
 with a fallen twig
sits
disconsolate
or so it seems
gazing out
at the emptiness
from
 painted by her
 who used to live unsequestered
melancholy bovine
orbs

Shared PET Imaging

we see the truck
words in bright blue letters

glance at one another
wondering

together
inside the car

we think
small adorable white dog

one as unlike our own
as we can think

licking our hands with small pink tongue
showing some joy at our return

no more than four hours later
on another high-speed road

a small adorable white dog
runs in the dark against the traffic

ears back, muzzle open
in a wide smile at its own cleverness

(do not cringe
it is a happy-ending story)

traffic even of SUVs
stopped momentarily to save

adorable white dog
restored to grateful owner

who recedes on a snow-covered street
black leash in hand dog grown nearly invisible

much like the particle embodied energy
of our collective love-starved imaging

In Dream

in dream
clouds shouldered their way
past me
looking
like the familiar
purplish fade
of a longtime bruise
hand
could not get a hold
up over
slopes
so insubstantial
even in dream
even
as I swam
past
that reminder
of hurt
toward
an aperture
beckoning
perhaps
not benignly
but who could suspect a Fra Angelico
sky

Surface Tension

only a skin keeps us
from that parallel world

elliptical track with the signposts
we pass each year in oblivion or gashed remembrance

yet those lost to our quotidian lives
regard no hierarchy

so the night of your grandmother's death
fifteen Octobers away now

hides a dear wrinkle
a surgery scar that for a second

no longer holds, and the distance
between you and me only connecting through sound waves in space

opens to let me breathe on this autumn gust
scent of apples baking in your kitchen nearly a thousand miles off

tonight at dinner we three see the dog
performing his usual food dance

from the other room we hear lapping at the dog's water dish
we had talked of *el día de los muertos* and till now forgot

our ghost animal insistent but gentle
with his pink tongue licking at the scab of his absence

same as when another year, fingering threads of milkweed cocoons,
tips reached through to the silk on his ears

SHOWCASE AT THE CONVALESCENT CENTER

a pair of palm doves
 eyes red-rimmed
 fragile bodies tinted violet
society finches
 looking like white canaries
 saved from a fall inside a cocoa cup
and tiny zebra finches
 with exotic plumage
 meant to hide them
 among extravagance
 of tropics
now in an aquarium
 large to be sure and fitted
 with straw baskets as nests
 fluorescent lights on at all times
visitors' big faces huge bodies
passing passing passing
while birds in fright
try finding hiding places

this display
what evil joker's mind
or crass indifference

here in this place
where we warehouse
the old the broken lost
here where these captives
will never see sun's light

THOSE WHO BUILD (ARE NOT GAY THIS TIME—*PACE* WBY)

we do not care what
we sever
the artery of a creek a river
a woman who'll no more stroke the loved hand

we are making ourselves
safe
this frontier
like the Great Wall of China
will be visible
to the alien
eye of satellite or voyager
from otherworlds

only the hordes held back
waning moon faces of want
want only to work hard
in the worst kinds of ways
for the worst kinds of us

the hordes whose chief crime
is want and to want
not what's ours
but to burn up in the vineyards
for our bottle of wine at $2.99
to break backs
for our clean pool kitchen floor children
suffocate in the sweatshops
for our umpteenth pair of jeans
so we can mimic work

we are making ourselves safe
in inner space of our ever-diminishing scope
from wan moon faces
from unmated ululation
of the last ocelot

Thirty Six Replicas of Camel-Leg Bones

from adjacent hall
strains of "Fascetta Nera"
—an installation about Italy
merrily
crushing
skeletal Ethiopia

here
 soundless two-toed
 ankle bone three feet high
 looking like grape clusters on levers
 shoulder-high kneecaps floating on wires
 thigh joint above my head
these
single
legs
stand
poised
to begin
at judgment trumpet
their
 fleshless
 sandless
 aimless
clatter

Winter's Tale

how do you know this our melon
of light
sliced each day
toward crescent then sliver then
its full absence
an O of darkness
will not be all
there is

who told you shadows on huge polar-
bear pads
softly making their way toward you
will
not in the end
swallow
along with the day
you

what pulse stronger
louder steadier
than your small fluttering beat
quieted
that wild surge
to run
toward a bloody horizon
falling
all in a heap
into night

did that whisper by bed river sea hill-
side
bring little
by little
 like wily Papagayo
 from Raven's beak
hope
whole
an apricot

did not mother's voice

say
do not fear

the sun
 look
each day
muscles
winter
out
struggles
each day
nearer
warms his way
toward
us

First Thaw, March 1, 2003

drawn as a quivering needle
to that expanse shining darkly
in this blind afternoon sun
we clamber over mounds of the last winter storm
passing projects that look like other projects only
better, alas, better always than Detroit's
past Santa Monica's hideous statue
with the prerequisite blue mantle
we watch long-eyed girls who look like sisters
of your younger sister
hear them speak in pellucid vowels
that cut clear, strong, flowing
like rivulets under slurred New England snow

water recedes like a mirage
yet at last we begin breathing
salt
know once more we're back to a hypnotic amniosis
the laughing gull mocks stick figures on this sun-drenched strip
great black-backs drop and crack mollusks
on sand that like a giant squid makes of each step a suction cup

in the distance we see a man and something fey
a disembodied masque prancing above the beach
in tune to its own festival
we rush to see
master and Jack Russell pup
take turns at training one another
the man says, proud,
he's a devil
while the dog, ears cocking,
answers the question of lost stick
obligingly picking up a strand of seaweed
only to feel it crumble in his teeth
"I call him Bentley," the man says in South Bostonese,
"so my wife can say I gave her a Bentley for Christmas.
He loves it here."
light's angle growing each second more acute,
wise dog, we say
as we needs must take leave

Two Months Past Solstice

cold cracks the pavement
lips

hands suffer thin cuts
skin scales

hibernation seems such a good idea too late
yet we are driven

to look in wonder at this tarrying sun
bathing the last hips in glow-blood

to see the lilac already insanely like us
yearning toward green

Spring Phenomena

magnolia buds shed their velvet coverings
debutantes letting mantles slip from pink shoulders

blooms in seconds as if obeying the carpe diem sonneteers
flush fill like sails with wind drop darkly crushed

cherry and apple petals swirl in squalls
next day cover the ground—mock snow

marking paths for the young in rut taking to the altar—
air hangs thick with scent lilac and honeysuckle

Small Signs

sidewalks are still treacherous
ice clumps and patches hiding under new snow

wind still like a zombie
sucks at the brain

yet helios triumphant heats
glass while we expand as if in a greenhouse

birdfeeders abandoned testify
to speckled breast barred tail of cooper's hawk

but cardinal and chickadee have begun
tentative trills portending sex not fright

horizon incandesces lingeringly
glow briefly severed by mallard silhouettes

Vying with Olympians

i turn the key to stop the gasoline flow
but not all the way
so music still rises
car door open to barely yet perceptibly
autumnal breeze
I let string notes pierce almost to pain my ears
rinse and wring
them of reports: our past and present horrors—bodies floating
in Gulf waters children torn from mothers dogs
president only surveying like olympians from above
and just as stupidly indifferent—

at the edge of vision movement
on the gray fence a red spot
fretting
closer
now on a branch of the forsythia
fledgling neck
scrawny
with yet unfinished work
of cardinal malehood
cocking
head
taking in
then stretching
full body
voice box
ready
to contend
with no less than perlman
and beethoven

Spheres

wave rides wave
that carries new waves in its fold
a planet
solar system
universe
thrown
birthed
of song
beyond our poor dull ears

where every rutter swells
sings
till chords
resound
respond

the humble hated mouse
stretches to twice his size
lets forth
a volley of harmonies

the mighty humpback
full fathoms five
where we imagine silence
 slowly turning
 eyes
 to riches strange
belts out his arias
his alone
 till some youngster
 steals
 riffs on them
 and gets the love

elephants trumpet
our murderous approach
their keening
and amours
in language far above us

trees signal
in screams
 chainsaw! borer!
send deafening whispers

on wind-soaked pollen
each sexpot flower
vibrates
with siren sounds

the very stars play bounce ball
with these uncanny notes
 plucked from organic improbables
 made up of cosmic dust
then echo
amplify
into celestial concert
the ancients
on deep non-electronic nights
dreamed of

Walking Toward Solstice

it is the treacherous time of evening
when sun hangs sideways not in the least crepuscular
splashing from behind leaves houses

figures moving closer from the west
could be carrying uzis or walking pit bulls
all i see is blurs clothed in clatter of light
armor impregnable against my eyes

it is the treacherous time of evening
when russian olives let go full blast
perfumed message of opened blooms

i walk through honeyed air viscous with memories

our tree (before i knew about invasives)
planted as namesake
for you
intoxicating syrup of early motherhood
look
i said
kinglets flashing through silver blades of leaves
flitting
faster than thought
but not (before i knew)
as fast
as years

Born in Romania and a long-time resident of Michigan, Anca Vlasopolos has published *The New Bedford Samurai* (Twilight Times Books, 2007)—nominated for a Pulitzer prize and recipient of the Wayne State University Board of Governors Award; *Penguins in a Warming World* (Ragged Sky Press, 2007)—three poems nominated for a Pushcart Award; *No Return Address: A Memoir of Displacement* (Columbia University Press, 2000), awarded the YMCA Writer's Voice Grant for Creative Non-Fiction in 2001, the Wayne State University Board of Governors Award and the Arts Achievement Award in 2002; a poetry e-chapbook, *Sidereal and Closer Griefs* (www.origamicondom.org); chapbooks *Through the Straits, at Large* and *The Evidence of Spring*; and a detective novel, *Missing Members* (trans. *Miembros Ausentes*); as well as nearly three hundred poems and short stories, in *Barnwood, echapbook.com, Hawaii Pacific Review, Pirene's Fountain, Earthspeak, Goblin Fruit, Mud River Poetry Review, The Rambler, Porcupine, Poetry International, Visions International, Mascara Literary Review, Barrow Street, Adagio, Avatar, Nidus,, Short Story, Natural Bridge, Center, Evansville Review, Santa Barbara Review*, etc; *Arts at an Exhibition* and *The Poetry Harmonium*, a music and poetry compact disc collaboration with composer Christian Kreipke. She is associate editor of *Corridors* and professor of English at Wayne State University, where she is also vice-president of the AAUP-AFT union local.

CPSIA information can be obtained at www.ICGtesting.com
Printed in the USA
BVOW031642240212

283743BV00002B/9/P